EVERY BEND

GAIL BUTENSKY

BAMBOO
DART
PRESS

LOS ANGELES † NEW YORK † LONDON † MELBOURNE

Every Bend by Gail Butensky

ISBN: 978-1-947240-16-2

eISBN: 978-1-947240-17-9

For information:

Bamboo Dart Press

chapbooks@bamboodartpress.com

Curated and operated by Dennis Callaci and Mark Givens

Bamboo Dart Press 007

www.pelekinesis.com

www.bamboodartpress.com

www.shrimperrecords.com

List of Plates

For Greg, who always insists on seeing what is around the next bend…

INTRODUCTION

Our diaries can only be as interesting as the places that we go in our lives. The shorthand of your life might be the living breathing friends and family of yours that will attest to your greatness and shortcomings over tearful phone lines or high ceiling burials, or maybe that stretch of miniature landscapes you made over four years out of toothpicks and tinfoil. We don't usually know when we are revealing ourselves, and even then, we are usually fairly confident that those around us did not get much but a glimpse of it. After all, no one can afford to pay close attention. It is an expensive tab, even if we go Dutch at date's end.

Photographer Gail Butensky offers a concise ride of where she has been in this slice of life miniature that she has excised from boxes of overflow, undeveloped rolls and images friends have seen in zines and handmade postcards with her unique scrawl floating through run-offs and tributaries to get to us. She doesn't want to impress you. She doesn't even want you to know she is there. Do many people remember her even being present with a camera when she was with us in real time? The camera was an appendage, it was with her wherever she went and so you tended to forget about it in her presence until she snapped a picture of you when you were paying attention. In this book, Butensky's camera was tucked in a parka in Chicago, side-saddled in San Francisco, maybe in a canvas bag just outside of the retaining wall in Southern California, waiting for the moment to flash. She was a Snap comedian, improv sitarist, satirist for the well-read low rent. She still is.

It is not inconsequential that photographer Gail Butensky's other gig is as a landscape designer. As any photographer knows, half of the work in taking a good photo is the placement of objects in the frame. Brian Eno once discussed having his yard renovated and taking note of the landscape designer's eye that he had hired who implored him not to plant a specific variety of a tree in the south eastern corner as in twenty years, the shade of it would have large ramifications on the fauna and palette that he was simultaneously planting. To think of your initial work as nothing more than curing a canvas and watching that image come to over decades struck Eno as it struck me, decades from first reading the line as revelatory. Hell, you can certainly see the slow build tendons of *Music for Airports* grow more defined and richer over the years since it was released than the easily digestible *Here Come the Warm Jets*.

Butensky's diary is captivating for all of the reasons above. That picture of The Minutemen in front of the death mobile of a van with the three of them young & smiling has taken on such a deeper meaning over the ensuing decades since the vehicle was totaled and buried. A Muppet babied Big Black, an amorphous audience of misfits and miscreants not yet wearing their government issued conforming costumes. These photographs offer a portal back to that world.

Similarly, the richness in Butensky's other work close to the earth and birth, is breathtaking. The spark and splendor of youth has ignited an eye that digs in deep, nestled close to the subjects at hand today outside of cement coffined buildings and piss sticky pathways. The stillness and big empty, the chill in the air that I can feel in my big dumb numb toe at those frozen

scapes or early morning desert highways she has shot. These photos are free from the narrative of humankind, the skeleton campfire that has scattered to the wind come morning. They are here now in this form for us to get lost in.

No one moment can reveal any of us, but the repeated conversations, acts, or short stories, films, canvases of an artist's life do add up over time and get us as close to the soul of those that we don't know as we could ever hope to be. In Butensky's work you can see her clearly at times. Her nervous energy, her claustrophobic million ideas at once blender of a mind as well as the more pensive, meditative moments of her life in the brush or the abandoned kitchenette. She didn't know we were there, watching the photographer capture images. Spying out the gardener digging space for the future. This book is a short ride off of a four-thousand-acre pier. She would love to show you more, but has so much work left before her that she can't dilly dally as we say in our transplanted Midwestern parlance, for the light is changing—she can't be late.

– Dennis Callaci
1/28/21

EVERY BEND

The main reason I take photographs is to remember, to document. A road trip is a great opportunity to see something new around every bend. Sure, we had a place to be and we were travelling to it, but the journey... always looking out the window. Always seeing something else. Always wanting to be somewhere, the next place.

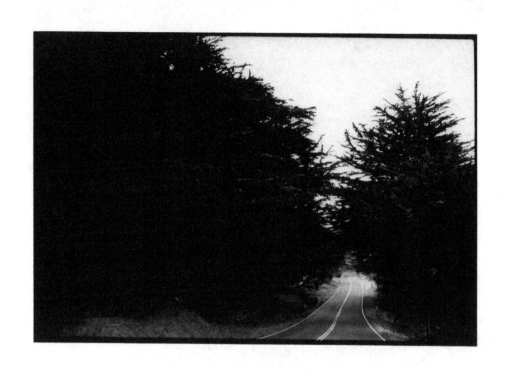

ON THE ROAD

The Minutemen loomed so large, and I never got to see them until their last tour- the ballot tour. D Boon's last. I asked them if I could take a few shots out on the street after the show in front of the van. That van. They posed, and they were dancing and having fun and just being so silly. I don't remember the name of this particular dance they were doing, but they did have a name for it.

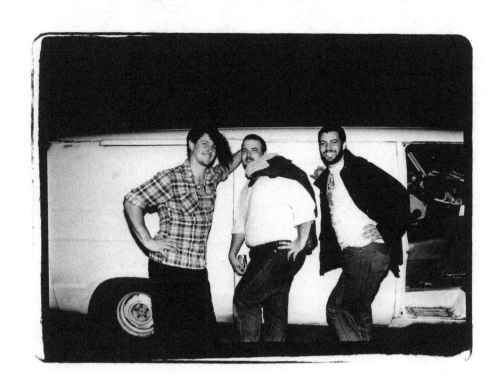

THE MINUTEMEN

It was so hot the day this photograph was taken. We'd been camping in the Mojave and thought it would be a good idea to climb up a crater. It was on the way home. We got here at noon and it was about 110 degrees. The brutal part of the desert.

After I turned purple from the heat we got back into the truck and went to lunch.

Still haven't seen the bottom of that crater.

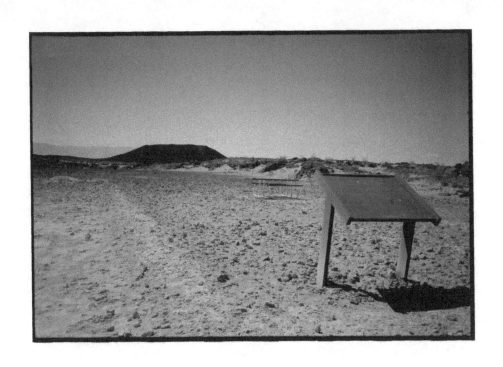

AMBOY CRATER

There was always a compulsion to document every place I stayed. Every motel room, every campsite. I was here. The camping chair claimed the spot, then we could settle in and then I could roam about and start photographing, several cameras at the ready.

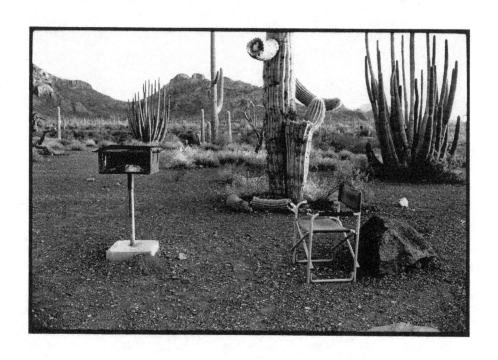

CAMP IN ORGAN PIPE

The Cows at the Pyramid in New York City, first time I saw them. What a crazy show. I was thinking, who is this guy with a cast on each arm? Not sure I ever got the story.

This is one of those photos that was happenstance, though so much may appear intentional. The raised hand, the framing, and the negative scratched just over Shannon's face. This was a nice surprise that jumped out from the roll of photos. When shooting live bands you never know if you have anything until after the fact. You might think you captured something, but you are never sure.

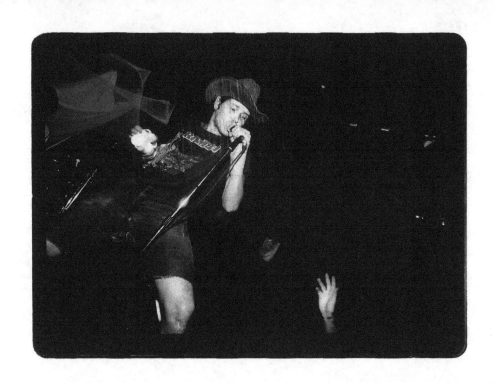

RAMBO

This was most likely at The Metro in Chicago. I saw Naked Raygun so many times back then. Hardcore was crazy, everyone jumping around and moshing. A lot of times I was on stage, or made my way to the front saying "excuse me, excuse me, excuse me." I had lots of cameras, I was pushy and I was a short girl. I took a lot of pictures. I stage dove once at a Butthole Surfers show at Metro. I was moving to New York the next day. I was backstage, and I remember thinking "this is it, I gotta go" and jumped off the stage into the crowd.

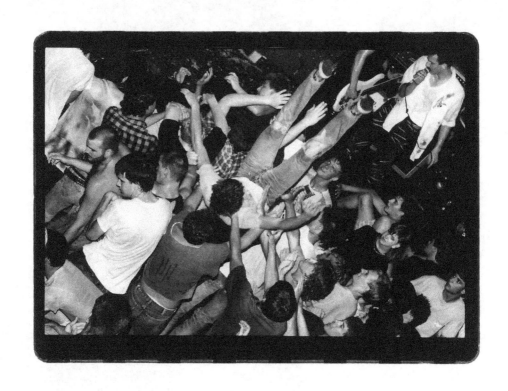

NAKED RAYGUN

We were always the last ones to check out of the motel in the morning. Then off we went, in search of breakfast. The empty dining room struck me as a time capsule, though not sure from when. You stumble on places like this less and less as everything is a chain now, everything is starting to look alike.

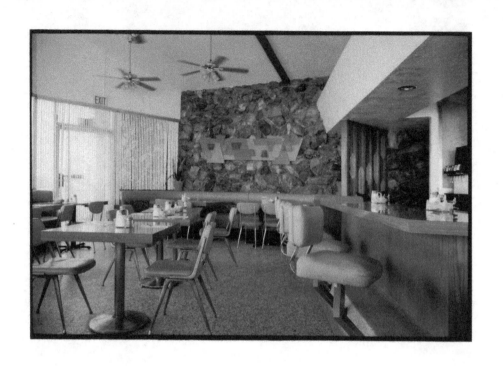

Breakfast

Big Black were playing later that night in New York City. They were staying at my place. I lived downtown near the Staten Island Ferry and we were just running about all day. We were old friends. I'd seen so many shows by then, and taken so many photos of them. Whatever city I moved to I was known as the girl with the camera. Often times I would be the only person at these shows with a camera. Now you go to a show and everybody is taking pictures because everyone has their phone and I take far fewer photos.

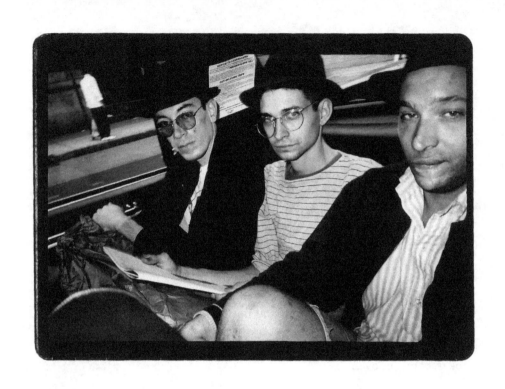

BIG BLACK

The Butthole Surfers stayed at my house on their first tour. They came through Chicago and hardly anyone knew who they were. They played the Cubby Bear Lounge, a baseball bar right near Wrigley Field that I lived two blocks away from. My roommates and I had a meeting the day before discussing how we could not have everyone passing through town staying at our place anymore. There was always a party going on, always bands sleeping on the floor, it was getting to be too much. One of my roommates and I went to the Butthole Surfers show because we liked their first record. The show was not packed. At the end of the show they were asking, "Does anyone know where we can stay?" so my roommate and I looked at each other and decided, okay, come on over.

In New York I would see them every time they came to town. This show at CBGB's was one of the most insane shows. I remember trying to get through the door and everyone was so high. It was so crowded and so hot that people were falling through the front door, it was hard to even enter. It was like a steam room filled with all of these people tripping. This photo is backstage, maybe 1987 or 1988. I guess I made it inside because this is backstage. It wasn't much of a backstage, it was CBGB's.

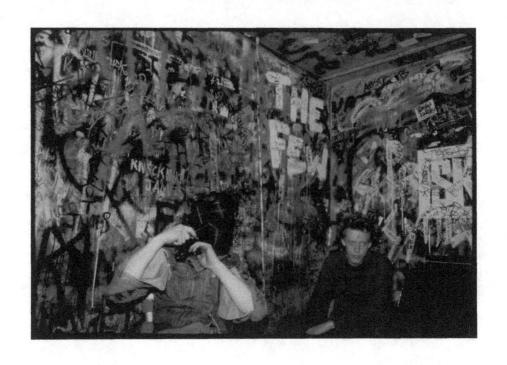

BUTTHOLE SURFERS

Driving out west, the roads at some point will always intersect with the trains.

Everyone is trying to get somewhere. I still take photos of the trains passing by, maybe because I want to hop on one.

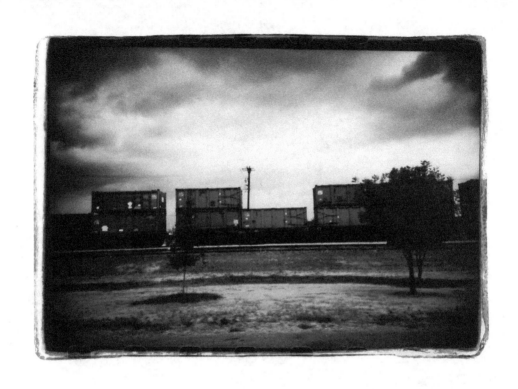

TRAIN OUTSIDE AMARILLO TEXAS

When I moved from New York City to San Francisco I was so excited because I figured I would eventually get to meet the Thinking Fellers. When their first album came out it was in heavy rotation amongst my crowd in NYC. We took a lot of photos together over the years, and they always had ideas. And props! For this shot they ran through this alley over and over again and again… the energy they had is apparent here! They had that energy as a live band as well, one of the best.

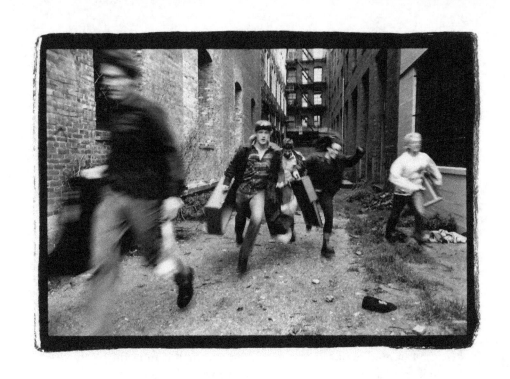

THINKING FELLERS UNION LOCAL 282

Over the years, I've sent a lot of photo postcards to a lot of people. Postcards remind you where you had been. I recently started sending out batches of photo postcards again, mainly because I have piles of old photos around and mail is fun. This photo is from a long road trip to Utah. We were trying to hike down to a very remote canyon. We had camped on the mesa at night. It kept raining, so we just sat in our sedan with low wheel clearance.

The following day we were getting ready for our hike and the ranger showed up. We were putting on our gear and he looked at us, and our car, and said "You have to get out of here now." It took us hours to get out of there. We kept seeing pools of water in the road and didn't think we could clear it. Wild explorers in a Cressida.

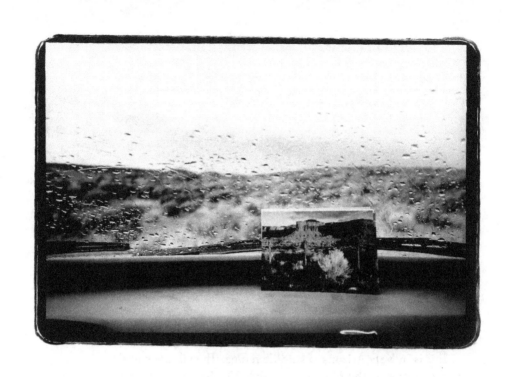

POSTCARD VIEW

This is in Kofa Arizona, a wildlife refuge. The vibrancy of this photo is due to the film type, AGFA 50, the choice of paper and how I chose to print it. This vibrancy was intentional. This type of film is incredibly saturated and contrasty and is no longer made. I was obsessed with this particular type of film, was hoarding it for a good while. I would always use this for photographs I would take out in the desert. I wanted it to look intense. There was a show I did with a series of these photos, and my seeing a group of them on the wall together appeared that they were screaming at me! They all had an insane vibrancy, almost neon. I dress and live in blacks and grays, muted colors.

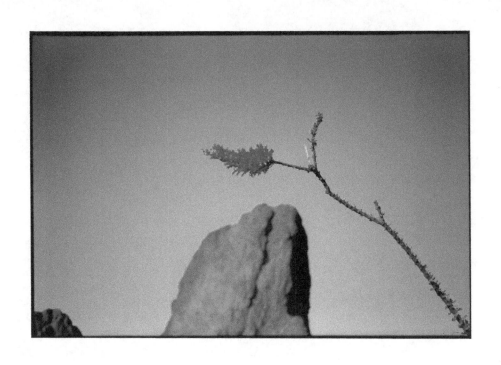

OCOTILLO BLOOM

Another show at CBGB's. It was our go to place and that's where the bands were.

I may have shot a roll, maybe less that night, but if you get one shot that you like then it is all worth it. The percentage of shots like this, "That's the one!" are so slim. You shoot so much in hope of getting something like this one.

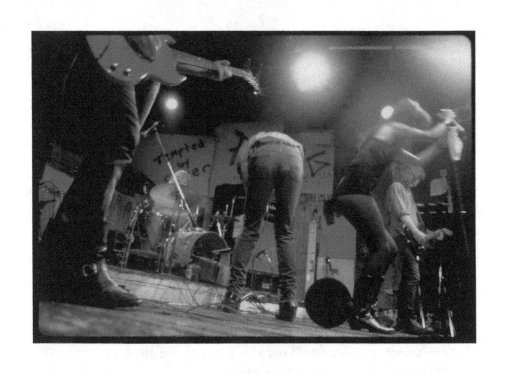

BOSS HOG

Two girlfriends and I were on a road trip from New York to LA and we had made a plan to go see Howard Finster. It was 1986. We were staying with a friend outside of Atlanta and all drove together to Finster's place. It was a good thing the friend from Atlanta came with us, because the guy at the gas station who gave us directions to Howard's house had such a thick southern drawl that us three New York girls had no idea what this man was even saying. Finster's nephew showed us around the whole site. A New York dealer had just bought out all of his work and Howard felt bad. He said, well here, you can paint. He took out a bottle and he started painting on the bottle, showing us how to do it since there was no art that he could give us. "It's easy," he said, so we sat there watching him paint.

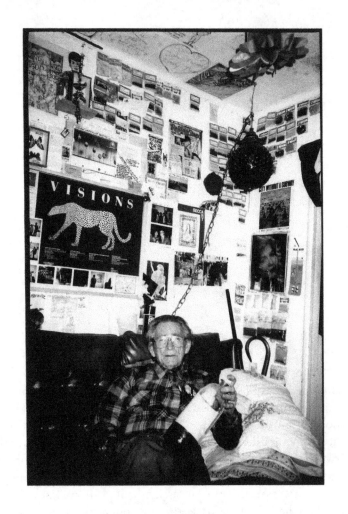

HOWARD FINSTER

I almost never take pictures of strangers. I don't know them and don't want to intrude. It is pretty rare that I take a picture of people if I don't know them, outside of assignments. I like shooting on the fly because it is messy, quick and easy. I want the instant gratification of seeing the image as soon as possible. I would then, and still do, view images before me as a photograph. I am used to seeing through a lens, used to looking at things this way. This was an assignment. I didn't know Jim. I like how he is looking back at me through the camera, it captures that, being a stranger being captured on film.

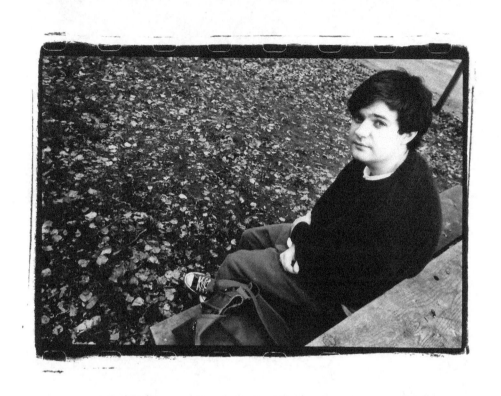

JIM O'ROURKE

It is difficult to see the perspective in real time when you are taking a picture. You can fiddle with the aperture, but it's not as obvious through the viewfinder. So many of my photos are by chance, I shoot something I am drawn to and am surprised. I often shoot something for fun, then decide to print it to see what it will look like. The habit of taking photos for so long has changed how I view things. I go on walks and I stop all the time to snap pictures, almost out of habit now. "This may be something."

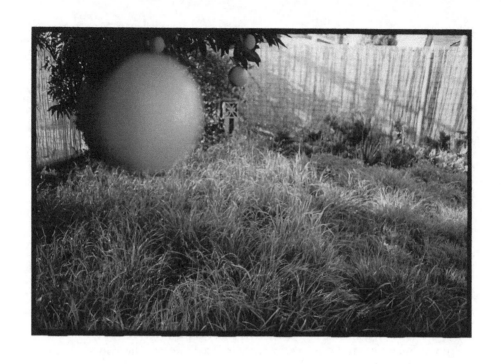

ORANGE TREE IN THE BACKYARD

I had seen The Violent Femmes prior to this, I think we borrowed Steve's car to go see them at their record release show in Milwaukee. Their record wasn't out yet, but we had their demo tape at the college radio station that I deejayed at, and a bunch of us decided that we had to go see this band. This is them in Chicago on their first tour. They were playing at the club just upstairs from where this photo was shot that evening. They used to busk in front of the subway so we said "let's go do that!" as there was an el-station right there. I took a bunch of pictures of them playing on the street. This was live and improv, but it was a set up. They weren't busking at the subway like they used to. It was a publicity stunt and really fun.

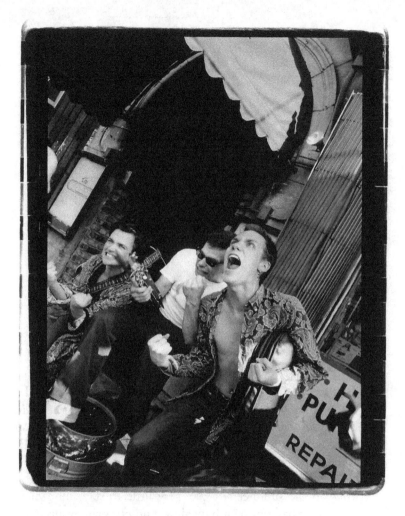

VIOLENT FEMMES

This was La Quinta in August, one hundred and fifteen degrees. A group of our friends were with us. The ladies were all in the pool, while the men golfed. It was so incredibly hot that you couldn't get out of the pool, so we were in the pool nearly the entire day. She was so peaceful. Floating still after everyone else got out. This was back in the day when you could go to Palm Springs in the summer and pay very little to stay somewhere fancy. We all had our own bungalows and our own group pool, living it up on the cheap.

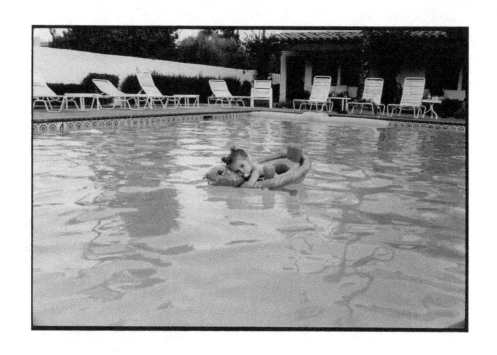

PIPER

When the first Pavement 7″ single came out (Treble Kicker), I was record shopping with Mark Ibold. He picked it up and said "Here, buy this." He wasn't in the band yet, we didn't even know them, but he knew that the single was a good record. He always recommended music to me that I might like and he was always right! This photo was shot right before (or maybe right after?) their first album, *Slanted and Enchanted*, came out. That cassette was going around for so long, everyone already knew those songs so well before it was released. So many shows and songs later…

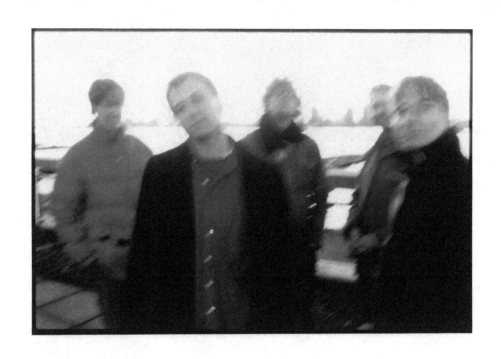

PAVEMENT

Vicki and I went along on a mini tour with Pavement. They came to play San Francisco and we drove up the coast with them. Those are all of the passes on the dashboard. They had no tour manager and the whole thing was so incredibly exhausting. I drove the Honda the whole way there and back since Mark and Vicky didn't have their drivers licenses yet. you don't get to sightsee too much on a tour, but I did get to see them play every night, so much fun. I remember we were in a hotel in Vancouver on our last night with the band and Nixon's funeral was on the TV after the show. Exciting after party.

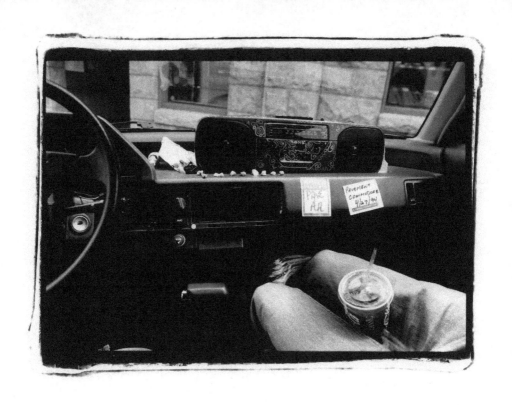

ON TOUR

This is one of the first photos I took in my "Where's Greg" series. When Greg and I would go on a trip, go camping, I would start setting up and then I would look around for Greg as he would always wander off. Where's Greg? Oh, he is climbing the nearest mountain. Okay. He would just disappear and start exploring. I would always see him from far away, usually in that magic hour light. There's Greg!

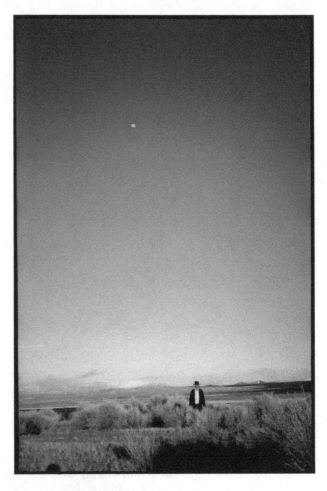

GREG AT MONO LAKE

Pull over! There is a sign, a plaque, something to see. Every time I took a trip somewhere, I made a book and these scrapbooks serve as my memory. I was documenting where I went or what I was doing, a record of those things. This is off the 395 near the Eastern Sierras. I don't recall what the sign was pointing to but the snowcapped mountains give it a location and perspective. What's there?

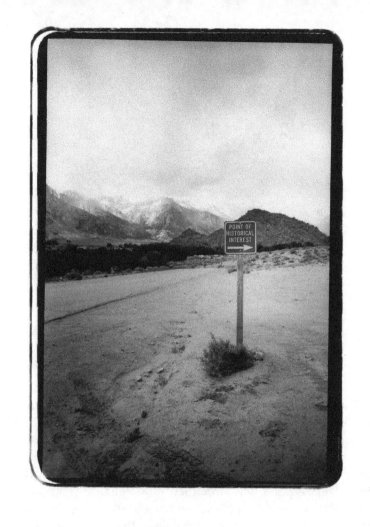

POINT OF INTEREST

Fuck are incredibly funny guys, the kookiest and sweetest people. They are hilarious. Sometimes they all dressed up for the shoot. I knew Tim back in New York before he was in the band. We all found each other, this time in San Francisco. Again, I knew them, the subjects, and that is visible in this photo. By the body language and how close they are standing together, you can tell that they all get along. In many band photos the band may try to be aloof, but not these guys. They are saying "here we are."

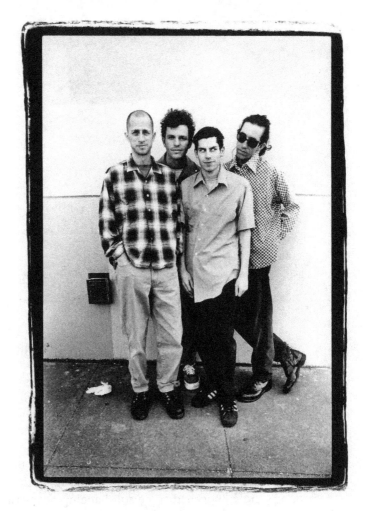

FUCK

This is a photo of the back of the band Fuck's van after a show. That sign was on stage when they played. They would flash the applause sign after a song. This was at two in the morning, they were packing up and I happened to be still hanging out with friends, drunken goodbyes as the club closed, see you again soon....

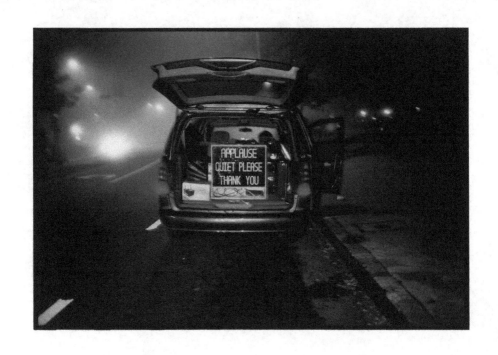

Applause

Always looking out the window, always comparing the vehicles. Maybe I can get one of those and just stay here on the road. Always going somewhere else, like a turtle with my house on my back. Further, further still to go.

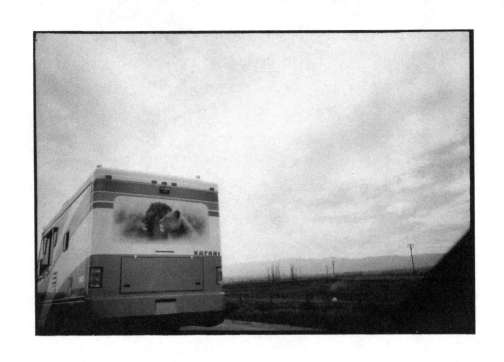

ON THE ROAD AGAIN

About the Author

Gail Butensky is a noted photographer whose work you may recognize from the records in your collection (Big Black, Thinking Fellers Union Local 282, and the band Fuck among others), the books *Our Band Could Be Your Life*, *CBGB & OMFUG: 30 Years*, and Bob Mould's *See a Little Light*. Or perhaps you saw her work in *The San Francisco Guardian*, *The Village Voice*, or *The Chicago Reader*, cities she chronicled when she lived in each of those major metropolitan areas. In *Every Bend*, Butensky's work in each of these venues is on display, as are intimate photos the artist shot outside of the music scene that she has documented for decades. *Every Bend* is a collection of photographs sequenced by Butensky to resemble a road trip with diary entries for each encampment that is presented here. A fascinating journey and a feast for the eyes.

112 N. Harvard Ave. #65

Claremont, CA 91711

chapbooks@bamboodartpress.com

www.bamboodartpress.com

CPSIA information can be obtained
at www.ICGtesting.com
Printed in the USA
BVHW011804140521
607367BV00009B/1221